# The Art of
# VAN GOGH

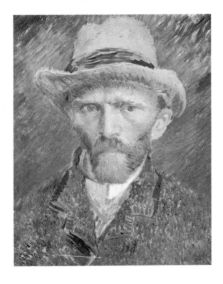

# The Art of
# VAN GOGH

—

Ariel Books

Andrews and McMeel

KANSAS CITY

10  9  8  7  6  5
ISBN: 0-8362-3018-3
Library of Congress Catalog Card Number: 91-77091

# Introduction

In August 1880, twenty-seven-year-old Vincent Willem van Gogh resolved to become an artist. His life up to that point had been a troubled search for meaning. In the next ten years, van Gogh would translate his internal doubt into some of the most beautiful and moving self-expressions in the history of art.

Gathered here are reproductions of some van Gogh masterworks—some familiar, others not—all testaments to the genius of Vincent van Gogh.

# A Chronology

1853   Vincent Willem van Gogh, eldest son of Protestant clergyman Theodorus van Gogh and Anna Cornelia Carbentus, is born on March 30, in Zundert, Holland.

1861–68   Vincent attends school in Zundert for one year, spends two years at a boarding school in Zevenbergen, and then eighteen months at the Willen II grammar school in Tilburg.

1869–80   In 1869, Vincent begins working for the international art dealer Goupil

& Co., headquartered in The Hague. He spends some time working at branch offices in London and Paris. Vincent grows to despise the art trade and begins an intensive study of the Bible. He is fired from his job in 1876 and returns to his parents' home in Etten. After failed attempts at teaching in England and missionary work amongst Belgian miners, Vincent resolves in August 1880 to become an artist.

1881–84   Vincent begins to train himself by copying the works of Jean-Françoise Millet. During this period he also receives training from his cousin Anton Mauve. Van Gogh's younger brother, Theo—em-

ployed by the art dealer Boussad & Valadon—becomes his chief financial and personal supporter.

1885–86  Working in his native Holland, Vincent begins to develop a unique style influenced by Millet, Rubens, and Japanese prints. It is in this period that he dedicates himself to painting peasant life; he also begins painting still lifes. In 1885, Vincent produces what will be recognized as his first masterpiece, *The Potato Eaters*. In 1886 he joins Theo in Paris.

1886–87  In Paris, Vincent befriends Henri Toulouse-Lautrec and begins an intense study of impressionist painting. He

also becomes more and more influenced by Japanese prints. Vincent meets Seurat, Gauguin, and Pissarro, and his work is exhibited.

1888–89 In February 1888, Vincent leaves Paris for Arles in the hopes of finding tranquility. He lives in Arles alone and in poverty until October of 1888, when he is joined by Paul Gauguin. The two frequently quarrel. On December 23, 1889, Vincent mutilates his right ear after a fight with Gauguin. Severely depressed and suffering from hallucinations, Vincent voluntarily enters an asylum in Sain-Rémy in April 1889, where he continues to work

despite his illness. He often works outside the asylum, and in the summer he paints his famous nocturnal scene, *The Starry Night*.

1890   Vincent leaves the asylum in April, visits his brother in Paris, and journeys to Auvers. There, Vincent enjoys a final burst of creativity, producing dozens of works that depict the local landscape. On July 27, he shoots himself in the chest. Vincent van Gogh dies on July 29, 1890, in Auvers.

# The Art of
# VAN GOGH

# POLLARDED BIRCHES WITH WOMAN AND FLOCK OF SHEEP

March 1884

Pencil, pen

—

*Rijksmuseum Vincent van Gogh,
Amsterdam*

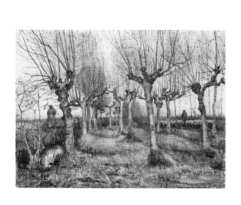

# COTTAGE WITH DECREPIT
# BARN AND STOOPING WOMAN

July 1885

Oil on canvas

—

*Private collection*

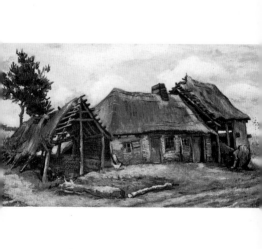

# PLASTER STATUETTE,
# SEEN FROM THE BACK

April–June 1886

Charcoal

—

*Rijksmuseum Vincent van Gogh,*
*Amsterdam*

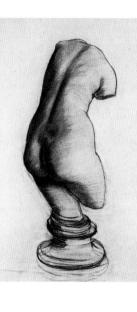

# THE MOULIN DE LA GALETTE

Early 1887

Ink and black chalk

—

*The Phillips Collection,
Washington, D.C.*

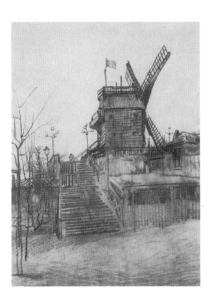

STILL LIFE WITH
TWO SUNFLOWERS

July–September 1887

Oil on canvas

—

*The Metropolitan Museum of Art,*
*New York*

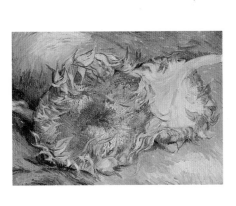

# STILL LIFE WITH
# FOUR SUNFLOWERS

July–September 1887

Oil on canvas

—

*Rijksmuseum Kröller-Müller, Otterlo*

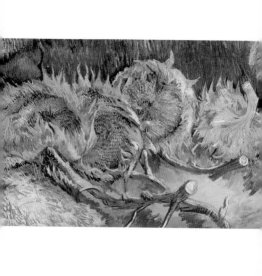

# DRAWBRIDGE WITH CARRIAGE

### April 1888

Oil on canvas

—

*Rijksmuseum Kröller-Müller, Otterlo*

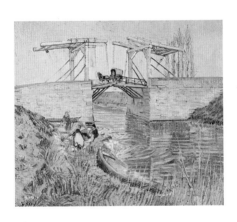

# WALKING COUPLE *(Fragment)*

March 1888

Oil on canvas

———

*Private collection*

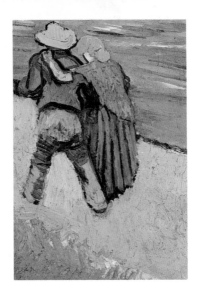

# LITTLE SEASCAPE AT
# SAINTES-MARIES-DE-LA-MER

June 1888

Oil on canvas

—

*Pushkin State Museum of Fine Arts,*
*Moscow*

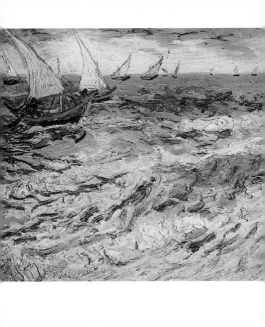

# THE SOWER

July 1888

Pencil, reed pen

———

*Private collection*

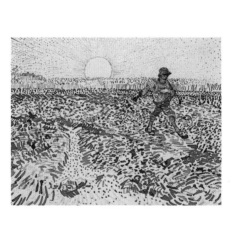

# MOUSMÉ, SITTING IN A CANE CHAIR, HALF-FIGURE

July 1888

Oil on canvas

—

*Museum of Fine Arts, Boston*

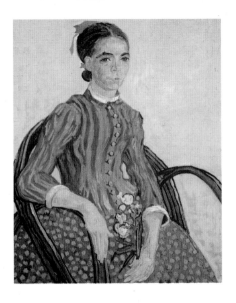

# PORTRAIT OF
# PATIENCE ESCALIER

July 1888

Oil on canvas

———

*Private collection*

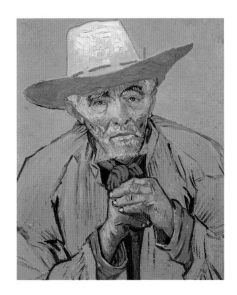

# FISHING BOATS AT
# SAINTES-MARIES-DE-LA-MER

August 1888

Pencil, pen

———

*Solomon R. Guggenheim Museum,*
*New York*

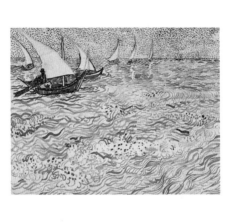

# PORTRAIT OF JOSEPH ROULIN

August 1888

Oil on canvas

—

*Museum of Fine Arts, Boston*

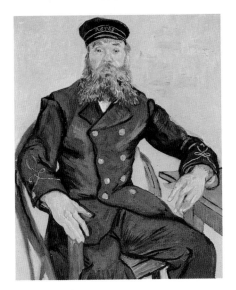

# JOSEPH ROULIN

August 1888

Pen

—

*Private collection*

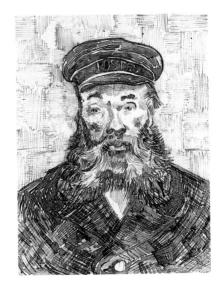

# FOURTEEN SUNFLOWERS
## IN A VASE

August 1888

Oil on canvas

—

*National Gallery, London*

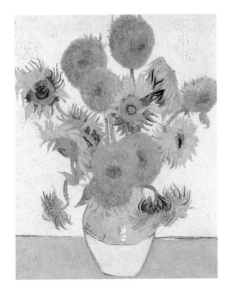

# A PAIR OF SHOES

September 1888

Oil on canvas

—

*Private collection*

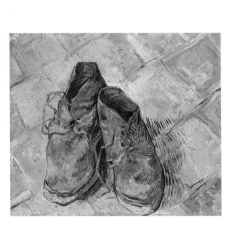

# THE NIGHT CAFÉ

September 1888

Oil on canvas

—

*Yale University Art Gallery,*
*New Haven*

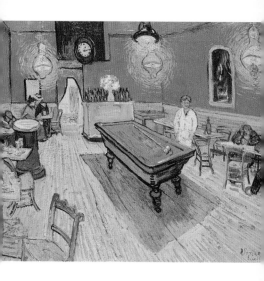

# CAFÉ TERRACE
# ON THE PLACE DU FORUM

September 1888

Oil on canvas

———

*Rijksmuseum Kröller-Müller, Otterlo*

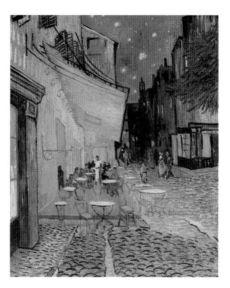

# VAN GOGH'S BEDROOM

October 1888

Oil on canvas

———

*Rijksmuseum Vincent van Gogh,*
*Amsterdam*

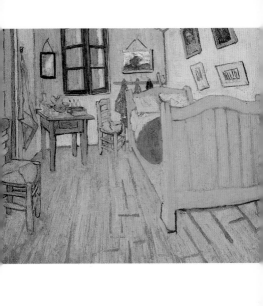

# VAN GOGH'S CHAIR

October 1888

Oil on canvas

—

*National Gallery, London*

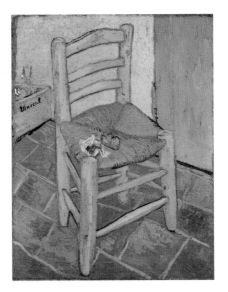

# SELF-PORTRAIT WITH BANDAGED EAR AND PIPE

January 1889

Oil on canvas

—

*Private collection*

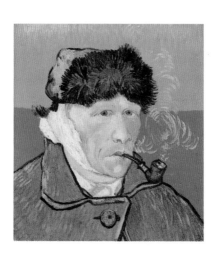

# PORTRAIT OF DR. FÉLIX REY

January 1889

Oil on canvas

—

*Pushkin State Museum of Fine Arts,
Moscow*

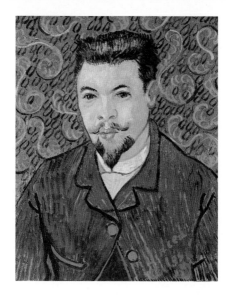

# STONE STEPS IN
# THE ASYLUM GARDEN

May 1889

Pencil, black chalk, reed pen and
brown ink, watercolor, gouache
on paper

—

*Rijksmuseum Vincent van Gogh,*
*Amsterdam*

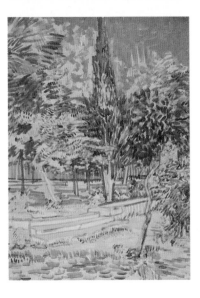

# OLIVE GROVE

June–July 1889

Oil on canvas

—

*Rijksmuseum Kröller-Müller, Otterlo*

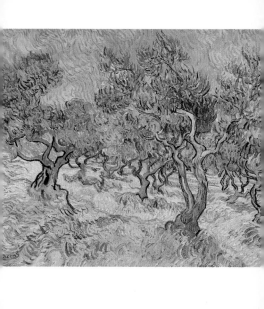

# WHEAT FIELD WITH CYPRESS

September 1889

Oil on canvas

—

*National Gallery, London*

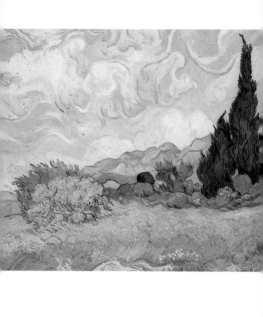

# PEASANT WOMAN CUTTING STRAW (AFTER MILLET)

September 1889

Oil on canvas

—

*Rijksmuseum Vincent van Gogh,*
*Amsterdam*

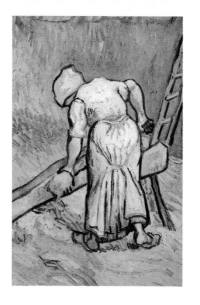

# THE ARLÉSIENNE (MADAME GINOUX), WITH LIGHT PINK BACKGROUND

February 1890

Oil on canvas

—

*Rijksmuseum Kröller-Müller, Otterlo*

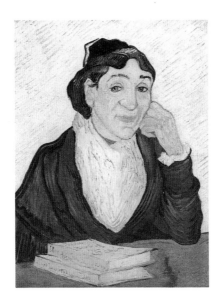

# STILL LIFE WITH IRISES

May 1890

Oil on canvas

—

*Rijksmuseum Vincent van Gogh,*
*Amsterdam*

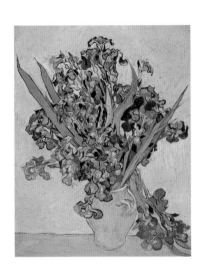

# ROAD WITH MEN WALKING, CARRIAGE, CYPRESS, STAR, AND CRESCENT MOON

May 1890

Oil on canvas

———

*Rijksmuseum Kröller-Müller, Otterlo*

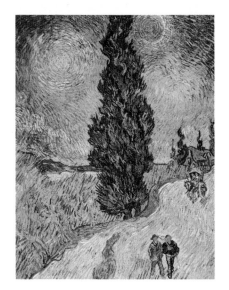

# THE CHURCH AT AUVERS

June 1890

Oil on canvas

—

*Museé d'Orsay, Paris*

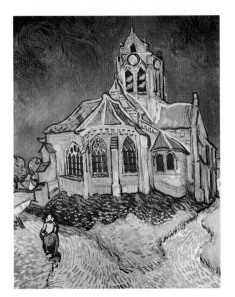

DOCTOR GACHET
SITTING AT A TABLE
WITH BOOKS, AND A GLASS
WITH SPRIGS OF FOXGLOVE

June 1890

Oil on canvas

—

*Private collection*

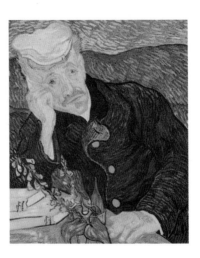

# WHEAT FIELDS

July 1890

Oil on canvas

—

*Bayerische Staatsgemäldesammlungen,
Munich*

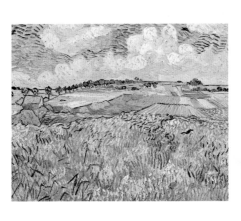

The text of this book was set in
Palatino by Dix Type Inc. of Syra-
cuse, New York.

Book Design by Susan Hood.

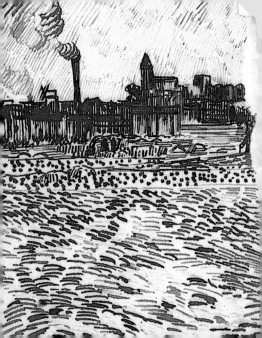